The Darker Fall

The
Darker Fall

POEMS

Rick Barot

Winner of the 2001
Kathryn A. Morton Prize in Poetry
Selected by Stanley Plumly

Sarabande Books
LOUISVILLE, KENTUCKY

Managing Editor
Sarabande Books, Inc.
2234 Dundee Road, Suite 200
Louisville, KY 40205

LIBRARY OF CONGRESS CATALOGING-IN-PUBLICATION DATA
Barot, Rick, 1969–
The darker fall / by Rick Barot.— 1st ed.
p. cm.
ISBN 1-889330-74-4 (cloth : acid-free paper) — ISBN 1-889330-73-6
(pbk. : acid-free paper)
I. Title.
PS3602.A835 D37 2002
811'.6—dc21 2002001373

Cover image: *Me and the Moon*, 1937 by Arthur G. Dove. Wax emulsion
on canvas. Provided courtesy of The Phillips Collection, Washington, DC.

Cover and text design by Charles Casey Martin.

Manufactured in the United States of America.
This book is printed on acid-free paper.

Sarabande Books is a nonprofit literary organization.

Funded in part by a grant from the Kentucky Arts Council, a stage agency
of the Education, Arts, and Humanities Cabinet.

Special thanks to the following most generous supporters:
Anonymous (3), Anne Axton, Dick and Jeanne Fisher, John Jacob, Peter
Saunders, Douglas Sharps and Susan Griffin, and The Sunshine Fund.

FIRST EDITION

to my father and to my mother,
to my sister

Contents

———

Acknowledgments / ix
Foreword / xi

I.

Reading Plato / 3
Eight Elegies / 5
Chroma / 10
Bird Notes / 12
Bonnard's Garden / 16
Botanicals / 18
Study / 21
Blue Hours / 23

II.

Riffing / 29
Passagework / 31
Sublet, Pitt Street / 35
Three Amoretti / 37
Nearing Rome / 40
Ocean Park Notebook / 42
The Gecko / 45
Portishead Notebook / 47

III.

Aubade / 53

Phantasmal Cities / 55

Montale / 60

Wittgenstein / 62

Interior with Extension Cord / 66

Photographing the Snow / 68

At Point Reyes / 70

Miró's Notebook / 72

The Author / 77

Previous Winners, The Kathryn A. Morton Prize in Poetry / 79

Acknowledgments

———

I gratefully acknowledge the following publications for publishing these poems: *Black Warrior Review:* "Eight Elegies," "Ocean Park Notebook," "Reading Plato"; *Colorado Review:* "Portishead Notebook"; *Epoch:* "Miró's Notebook"; *The Georgia Review:* "Chroma," "Riffing"; *The Gettysburg Review:* "Wittgenstein: On Color"; *Grand Street:* "Bird Notes"; *New England Review:* "At Point Reyes," "The Gecko," "Three Amoretti"; *The New Republic:* "Aubade"; *The Paris Review:* "Phantasmal Cities"; *Ploughshares:* "Bonnard's Garden"; *PN Review:* "Photographing the Snow"; *Poetry:* "Montale," "Occupations"; *Prairie Schooner:* "Cloud-Horse," "The Exile"; *Southwest Review:* "Wittgenstein: On Certainty"; *The Threepenny Review:* "City Entries," "Inventory," "Study"; *TriQuarterly:* "Botanicals"; *The Yale Review:* "Nearing Rome"; *The New Young American Poets* (Southern Illinois University Press, 2000): "Portishead Notebook," "Riffing," "Three Amoretti."

I owe much and more to the Creative Writing Program at Stanford University for its support. A poetry fellowship from the National Endowment for the Arts was also of invaluable help. Finally, for their unfailing good will, I salute Gabrielle Calvocoressi, Peter Campion, Michael Dumanis, Andrew Feld, Brett Foster, Tamara Guirado, Benjamin Kleaveland, Katherine Lederer, Karim Logue, Joanie Mackowski, Cate Marvin, Michael Osborne, ZZ Packer, Salvatore Scibona, Brian Teare, David Yezzi, Monica Youn, C. Dale Young. And Jonathan Liebson.

Foreword

———

The first responsibility of poetry is, of course, language—not *a* language but *its* language, the poem's absolute sense of itself as an aural, visual, and, most of all, palpable experience. Perhaps even a complexity of experiences. Those who believe in language as an end see language as the end of the experience. Others, like myself and Rick Barot, who believe in language as a means, understand it to be the means to another end, perhaps meaning, perhaps the language of the experience. That unparaphrasable experience used to be called content. More likely it is the contents contained in, generated by a poem. What we still sometimes call form under-writes the content.

Barot's first collection, *The Darker Fall*, is a brilliant example of language as means, as an art nearly flawless in its transformation of emotional and actual sources. It is a book fundamentally gifted in the grammar of its experience. This gift is as essential as sentence-making and as metaphysical as the imagination. On the one hand, Barot creates an energy of duration that sustains as much as it surprises; on the other, he allows the mind to move at its own meditative, speculative speed. At both levels he never permits the anxiety of the content to out speak the scrutiny of his form.

The feeling never overtalks the thinking, a fact remarkable in a first book—honesty riding the thought. Which is why Barot's interiority reads so effectively exterior. He broods not in a world but in the world. "Battersea Bridge" could be a moment out of a Thames mood piece by Whistler.

Like signals indistinctly coming through,
the riverboats are bare blebs of light.
The next bridge is a sketch of bridge,
an arc between posts. Is there a more human
habit than this—to stand here, looking out,
letting our natures yield to all we see
so that the streets, narrowing away
to the world's edges, begin to stand for
our longings? The fog slagging over the city
would stand for our dreaming were we
sleeping, but sign after sign proves
the night OPEN OPEN OPEN. The day's grudges
are on the last trains to the suburbs.
And love, insomniac, burns in the factories.

Such fine-boned sensibility might be precious without the muscular hand-eye coordination that lifts the visual detail here into an empathic vision, an embracing correlative that brings us right into the imaginative picture. The fourteen lines are filled, even expansive, with the balance of sight and speculation, sharp-eyed accuracy and epiphany. This is the dreamy night, reverse version of Wordsworth's dawn revelations from another famous bridge on the Thames. Postmodern, certainly, but no less Romantic in its intensity and insomnia.

Barot's mature linguistic skills really come down to a metaphorical and musical intelligence that refuses to value one element over another, that will not let the language or the longing take over. Thus the ease, the warmth, the inclusiveness, the confidence of his writing, and thus the impression of wholeness of its purpose. Take any commonplace observation, say of a familiar—of a blue jay—and the object turns into an implicative, animated still life.

Thought-fast, so that
what was a branch-caught
milliner's flounce
became the confectionary
opera shoe lobbed outside
to the tune of infidelity
being played inside,
the bird almost lost
into its disguise
when it rustled off
to a new branch and turned
flag for the sky,
only to turn tail again,
more hidden this time...

This is elegance, yes, but its thesis is played to the "tune of infi-
delity," an inside-outside theme, separated by windows, for which
the restless jay, not unlike James Wright's blue jay in "Two Hang-
overs," is the anxious representative. Barot, nevertheless, makes
no big deal of it all, building by distraction and understatement a
figure capable of at once correlating while commenting on poten-
tially comic human failure. The bird both turns "flag for the sky"
and "tail again," before becoming "more hidden this time." The
parallel snap narrative of this domestic scene, resolved in
metaphor yet separated by circumstance is a typical tension in
Barot's poetry. He works so quickly between stations, however,
and operates with such combining force, without ever sacrificing
stability, that the effect is one of buoyancy, generosity, as if, ever
so much, gravity had been suspended.

But by no means altogether. Gravity is what gives Barot's
poems their quiet beauty. Gravity of the elegy and the love poem,

the meditation and celebration, is what secures the lines of the interconnections, the weaves, the overlappings, and the leaps this poet is so fond of. Gravity is what weighs and measures the heart, the open-mindedness of the poems. And finally gravity supports the tone of acceptance, comprehension, reconciliation, and arrival that unifies the work as a whole. Whatever crisis or confusion may plot their inspiration, these poems achieve wonderful clarity and resolution. A kind of emotional equanimity seems to be the key, a quality of disinterestedness or what Keats called negative capability, which result is positive and intimate with those depths in us that only good poetry can reach.

—*Stanley Plumly*

ONE

Reading Plato

I think about the mornings it saved me
to look at the hearts penknifed on the windows
of the bus, or at the initials scratched

into the plastic partition, in front of which
a cabbie went on about bread his father
would make, so hard you broke teeth on it,

or told one more story about the plumbing
in New Delhi buildings, villages to each floor,
his whole childhood in a building, nothing to

love but how much now he missed it, even
the noises and stinks he missed, the avenue
suddenly clear in front of us, the sky ahead

opaquely clean as a bottle's bottom, each heart
and name a kind of ditty of hopefulness
because there was one *you* or another I was

leaving or going to, so many stalls of flowers
and fruit going past, figures earnest with
destination, even the city itself a heart,

so that when sidewalks quaked from trains
underneath, it seemed something to love,
like a harbor boat's call at dawn or the face

reflected on a coffee machine's chrome side,
the pencil's curled shavings a litter
of questions on the floor, the floor's square

of afternoon light another page I couldn't know
myself by, as now, when Socrates describes
the lover's wings spreading through the soul

like flames on a horizon, it isn't so much light
I think about, but the back's skin cracking
to let each wing's nub break through,

the surprise of the first pain and the eventual
lightening, the blood on the feathers drying
as you begin to sense the use for them.

Eight Elegies

I.

One kind of rain gets to be
exactly the rain you want, disbursing
lightly in its fall an atmosphere
that you walk into as into
a confetti rain, getting kissed while
umbrellas click like flashbulbs around you.

II.

She said, "I want whatever CD was in
the player, the shirt that was on the hook
in the closet, the earrings he gave me
that I gave back, the ugly
painting I made for him."
Her friend made sure to put back
the yellow police tape he had to take down
when he went for the things.

III.

Once, during a Midwestern blizzard,
I let in two Mormon missionaries
because I didn't want them believing

that the snow, the doors closed against them,
were a form of extra credit. Each one
was an Adam in a blue suit, blond,
clear-faced. Their bodies, because I spent the hour
imagining them, were clean as statues:
above the hipbone, above the knee, a cord
of muscle; each shoulder was soap-smelling.
I made coffee and tried to listen,
my stomach felt raw with meanness.
Later, telling a friend the story, I understood
I had failed at a charity
that went beyond having faith.
We were by the river, the water full of broken
ice-plates. My friend told about
his grandmother scolding him for ironing
a shirt's bottom, the part that would get wrinkled
anyway. The snow, held briefly,
faded into the heat of his hair.

IV.

Wanting death, which of the senses
would the mind kill first?
My sister's lover, tying knot after knot
in practice, would he have heard
the traffic humming in the air,
the steady undercurrent? Would he have felt
the cat's tongue, the sandpaper
dampness against his arm?
Did memory, shaking away bracelets

6

and scents, leave the room?
And love, piece by piece, light as a nest?

V.

In a poem I keep returning to,
there is so much hunger
that a man gets killed for the few bills
he has in his pockets. In the café,
telling himself to leave something
for the waiter, the murderer has a blizzard
of words in his head: *coffee*
and *toast* muddling into *rum* and *fare*.
What always startles me
is that he should have any words
coming to him at all, the words
composing the day and all that he did in it.
The same way, blocks from home
and not about to turn back, I'm stuck
thinking of *coat*. Or my sister,
in the restaurant kitchen where she works,
thinking into *knife* and *basil*
so clearly that she becomes the knife,
becomes the basil. In a book
of paintings I look at, there's a color
the artist calls *gris clair*,
a color like onionskin floating on water.
In one painting the sky is this color,
with hills below overlapped in vellum shapes.
I think of the painter going home, exhausted

by his own attention: *gray, boulder,*
night, and *hydrangea,* each word
completed by his love and by his care.

VI.

I slept there once, his walk-up room
a perfect brick cube.
The wood floors were scratched at
as though an animal had been kept there.
The windows had an airshaft
view, and opened to the noise
of air conditioning and the quarreling
of taxis. I woke to humidity,
heavy as a blanket on me.
The air smelled of cat litter and diesel.
But walking out of the building,
to every color the day had,
I knew I was in a great city.

VII.

She didn't open the small box,
put it on the floor so that
in a few weeks the things of her room
seemed to pity it: first surrounding it
like figures around a fire,
then covering it altogether, the shopping bags
and the coats, the sweaters, the socks.

VIII.

One kind of rain has you
at the bus-stop at five o'clock,
on the sidewalks a gruel of newspapers.
Walking there from work, I had seen
an old man suddenly stop,
bend to the gutter, and let out
a yellow sleeve of vomit.
The rain wasn't snow
but seemed determined to be.
I wanted the day spooled back,
all the way back, to the dark under
the dresser, the dark inside cabinets,
inside suitcases and bottles,
all the way back, to the night
I argued with a friend's voice on the phone,
went outside to have a cigarette,
and saw the woman made-up
so garishly that there was no question
she meant to have you look
at the orange pile of hair,
the red pumps, the trailing tinsel boa,
her quick soft laugh carrying now
night into night into night.

Chroma

A rain-mixed neon smear
to start: a puddle's palette
blending blond washes
from the Go-Go Girls sign

to the blue of a squad car's
lights and the reds of
Noodle Shop and Peking Duck.
All night these oddments,

usually taken for granted,
kept stopping us: the lucent
rose quartz medallions
lined on velvet trays among

the garden-variety greens
of jade; Seurat-dotted clumps
of lilacs in tin tubs
shedding their purple-white

pigments to the ground;
a pawnshop display's lexicon
of watches, rings, gold
chains, a trombone, and violin,

unstrung; freakish skin-white
roots pickling in jars, bins

of teas, shark fins,
and dried mussels shrunk

to labial apricot cupfuls...
What I knew then about
the shapes felicity can take
might have remained with

those things, had it not been
for the fireworks scatter
of busted glass we walked into
around a corner, beside it

a burlap rice sack spilling
more bottles and cans,
the squad cars just leaving,
the ambulance long gone,

a day's botch lived through
or not lived through,
its particulars already
beautiful: stained-glass grains

of Anchor Steam ambers,
clear Beefeater half pints,
Rolling Rock greens,
Red Dog reds, Guinness browns.

Bird Notes

i. cardinal

Though the rockabilly crest
and bandit mask
seem kinds of a kind
of avian kitsch, the deep
Benedictine red
of fall leaves and joss sticks
saturates his belly
and breast, while brown
smoke-gray threads
lightly stipple
his back, as if he too
had had to pass through
some fire, had to be saved
just to be here,
one more version of come
as you are, perched on
an owl-faced parking meter.

ii. crow

This snow is nothing.
It only simplifies what he
already knows
of branch, fence pole,
the collapsing shed
and last sore-spotted apples.
It's all the same
that the sky is ice-white
or plum-black, woodsmoke
waxing on its skin.
He has seen it all before.
He has been the one
enraged sound
on the day's unpronounced
hours, the staggering
thing someone comes to find
exterior to time.

iii. blue jay

Thought-fast, so that
what was a branch-caught
milliner's flounce
became the confectionary
opera shoe lobbed outside
to the tune of infidelity
being played inside,
the bird almost lost
into its disguise
when it rustled off
to a new branch and turned
flag for the sky,
only to turn tail again,
more hidden this time,
the shrub-snagged piece
of Persephone's dress
left to the snow and rain.

iv. hummingbird

Breaker of the sargasso
of midsummer,
beloved incidental—
a bottle-cap nest
could have contained him.
But even the dark
didn't keep his business
from continuing,
his bill's needle
singling out the lavender
while the blurred hinge
of his body and wings
steadied him.
And like the bulb
when its light goes out,
he left a blush
on the air he had occupied.

Bonnard's Garden

As in an illuminated page, whose busy edges
have taken over. As in jasmine starred
onto the vine-dense walls, stands of phlox,
and oranges, the flesh of each chilled turgid.

By herself the sleepwalking girl arranged
them: the paper airplanes now wrecked
on the vines, sodden, crumpled into blooms
which are mistaken all morning for blooms.

The paint curls out of the tubes like ointments.
In his first looking there is too much hurry.
Dandelions, irises smelling of candles.
Two clouds like legs on the bathwater sky.

Drawn out of the background green, getting
the light before everything else, the almond
tree comes forward in a white cumulus,
as though the spring had not allowed leaves.

Last night she asked what temperature arctic
water could be that beings remained in it.
Then the question brought to the blood
inside her cat, the pillow of heat on a chair.

His glimpse smudged. As in: it's about time
I made you dizzy. Here are pink grasses,

shrubs incandesced to lace, tapestry
slopes absorbing figures and birds and deer.

Nothing is lean. The lilacs have prospered
into bundles, the tulips fattened hearts.
Pelts of nasturtiums, the thicket the color of
pigeon: gray netted over the blueberry lodes.

Then the girl's scream, her finger stirring
the emerald tadpole-water, the sound
breaking into his glimpse for an instant
then subsiding to become a part of the picture.

Not the icy killing water. But the lives there,
persisting aloft. Like the wasps held in
by a shut flower at dusk, by morning released,
dusty as miners, into the restored volumes.

Botanicals

I. Cosmos Sulphurus

You can carry me there
only so far: to the boy's lips
blowing on the leaf,
pink and cool and dry,

to the roadside trash, spit,
and soot you lord over,
a few of you half living beside
the fence, one manner

of speaking that the day has:
king-purple, skinny
stems, the blossoms hollow as
ventricles when you close

for the night: seeing
carries me there only so far,
my incomplete half
coveting in spite of you

the hopscotch-chalked
pavement, the boiling eggs
knocking on each other,
the couple in a doorway's black

maw, the neighbors woken
and brought this
disquiet: the threat of storm
becoming actual rain

nailing down on the sulk of you,
heads inclined, made
amenable, your petals
already piecing into the chalk.

II. Bouquet of Hawthorne

Who will get taken. Who will
put the shimmering thing in its vase,
white buds on the antlers.
Who will give it up,
 unforced,
unmarauded. What strongbox notion
of self: clear, clean as the water.
Drop the aspirin. Trim the too-long branch.
Persuade.
 Who will get to decide
the translation: is it the severed head
in the stream, or the candy
of getting touched.
 You can be sheepish
for now. Be negotiable.
It's the fish that occasions the fishline
and the hook, the arm throwing out
its pelagic lines.
 Who has the heart.
Who will have the first and the last
word. After you. No,
after you. Who will be ahead this time
around.
 Drop the crushed aspirin, trim
the long branch. The thing will keep
for days.

Study

It has taken its time to come to it, the tree nearly
clean of leaves. With even a querulous wind,

something on it flurries into wing. How it must
happen: first, the leaves' release, then the limbs'

paralysis, frost on the wizened trunk like pollen.
Then each thing keeping to itself. The house

an entire thought to itself. This morning I saw her
take a coffee can of seed to the feeder, so cold

that her breath seemed a ghost-face always
in front of her. In brown explosive handfuls

the birds disbanded. Her work took long minutes.
Step and step, the feeder's lid removed, the can

aimed into it, then the steps back, the birds back,
the screen door slightly open, a dumb mouth.

In the afternoon, in the day's one warm hour,
he was up on a ladder taking down storm windows,

hosing them down, the paste-white sky reflected
when he tipped each wet square a certain way.

The tufts of one glove waved in his back pocket.
The other lay on the grass. It was there long enough

for me to see their room darkened, the clothes
heaped, the white alp of a foot underneath a sheet.

Blue Hours

I. Cloud-Horse

Knowing exactly what it needs
to do, carrying its own particle of worry,
or what passes for worry,
the spider hurries across the floor,
single-minded as a last, brave hoplite.
Other mornings the starlings
pick the lawn's seeds in practiced fours—
one keeps watch while the others
feed, always together.
Even the potted tulip leans into itself
unconflicted, canting its head
like a listener
to the room's brighter half.
So to enter these things, sweet and mannerless.
Hours now I have stared
at that picture, that horse
rushing over its gold field,
its walnut-brown body patched with tin-gray,
pure-white clouds. Red oaks
form a ragged fence on the horizon,
and I can imagine how the field, the tough
grass, are all the horse could ever
want, free to the last
of *What next? Where now?*
Where is the long day taking me now?

II. The Exile

All day I have made words
which fix my life
to the rhythm of
this day. I know
this hour's satisfactions:

tea coloring the water
in a cup, and birds, kindled,
as if of one mind,
shuddering out of trees,
then gone. The sun

falls below the familiar
line of roofs, and I
wait for someone who knows
I wait. Yet why
the old terror, the one

Seferis knew, sickened
with sensibility
as he stood on the ship
and watched the light
die over Sounion,

the cliffs still gold
while the hills turned blue?
He discovered himself
in the moment, and heard
the voices of others,

distant but calling.
Here, houselights blink on,
the breeze empties
of warmth. And more often
I catch myself

in these moments
when the light is scarcely
alive above the roofs
and I lean on the doorframe,
remembering the small

fires of everything gone.
I no longer know who
I'm waiting for. I ask
everything of the stillness.
I wait for everyone.

III. Inventory

Remember the cockroach rounding the cup's rim
as a thought for the self, itinerant, lately forgotten.

Add to it the ticking of the cat, and the radiator
shedding its white scabs of paint. Keep in mind

the books, which smell like an old man's clothes,
and take note of the nightly provisions of soap

and hot water. Notice the oranges outside Miss K's
piled in spruce pyramids, and the stray brown bags

on the street given body by the wind, lifted,
and released. Then remember: you are as young

as you will ever be. The taxis, beetle-shaped
and hurtling, keep carrying you away. And you think

the speed of the earth must be the secret
in the wonder of these things: the chair, the cup,

the mirror. The instants which turned to feeling,
leaving the stubs and ash as their simple report.

TWO

Riffing

The pit of some fruit might be what I'm about
to bite on, speech lapsing to bitterness
that way. Or it might be that a cloud
is paring away from the sun, the sun striking
meaning on something that has to shine.
From a limited meter, Frost says, endless
possibilities for tune. And so I love how
do re mi becomes another nature in my book.
How Tom, Dick, and Harry are all the same
but what I sing about them different.
Tom's little finger, let's say, or Dick's ear,
or that spare meadow of hair at the small
of Harry's back. I know someone who thinks desire
merely taffies the mind's one want, which is

to be free of want. But I don't live in a bamboo
grove, can't stare at the philosophical cranes
for more than a while. Clean paper only makes me
think of Tom's name repeating itself there.
And the privacy of each face in the subway crowd
suggests that any story *do* might offer
is so distant from what *mi* has to say
that there's no hope for the philosophical.
Someone might be speaking to someone in the dark,
a cigarette the only light between them.
Someone might be crying over a map.
Someone has just about polished a pair of shoes

to his satisfaction. I don't know how dreams
mean, but it's that shoe which often pulls

through to morning, the creases on its snout
like laugh-lines on a face. I think about it
while watching Harry's face waking to *its* lines,
its breath and words. Its *coffee* and *shower*
and *work*. I remember my mother planting roses
as one way the mundane gets brought into
sacredness, though it was simply a thing she liked
to do. Dirt and rain. Leaves and thorns.
Nothing about the fascination with what's
difficult. Nothing about how the soul, in its
limitedness, sings. Just one thing and then
another, Tom says, his tongue here and then here.
Each kiss different and yet somehow the same.
To one rose how many notes can you bring?

Passagework

I. City Entries

Noticed the stumble of Keats's handwriting
under the museum's glass case, and wondered how,
out of such transactions between will
and accident, beauty makes its monuments.

Just as, when we walked outside, the purple fumes
of the bus, shading into the charcoal
dusk, seemed the fleeting word of the day.

And, too, the shrug of a woman's shoulders
as she walked into the early chill,
her shoes' heels thudding on the concrete,
surface meeting surface.

Noticed the shiver of your hand as you turned
the slim stem of the glass, the half-globe of wine
warm, luminous.

There must have been tenderness
in that old waiter's voice as he scolded us
for our sidewalk table—"It's October!" he said.
And true, the wind lifted the tablecloth
like a skirt, burst a light bulb, and pushed
paper down the street like leaves.

Our few words had hardly anything to do with us.

We talked about Bonnard, how the rooms
in his paintings are ideas of quiet.
"Some days," you said, "I wish my mind
were like a bowl, empty and white."

Noticed the ache which comes with twilight
arriving, bulb-glass on the sidewalk. A siren,
briefly intense, seemed the unlikely grace note
of a music I often fail
to hear, like that one star the eye fixes on
sometimes, but always loses.

II. Occupations

Astronomer to the ten Turkish moons
counted out on your fingernails.

Surveyor to the shiny silicate scar
of the childhood cut on your brow.

Geologist to the fault-line crack
your wrist has long since healed from.

Treasurer to the coin of vaccination
darkly minted on your left arm.

Farmer to the stubbled acreage
of your chin, to the nocturnal root.

III. Fever

Below the surface and where
was I in that murk
that brain silt of summer
my parents hand on my forehead

bowl of ice under blankets
but still not warm as now
the unappeasable heat quieted
only by the pill's sift

like snow through the body
and awake, strange given
back to time the appearance
of this life comes back as

a room for two fridge hum
and rain outside clapboards
rotting shed paint flaking
tomato vine climbing rung by

rung as it must and rain
on the window and nothing but
no hobo face no can-man
muttering O muse of fire, O

no lost child no shagbark
figure but keys, pen, calendar
bird trochees coming through
before sleep me you me you

Sublet, Pitt Street

The graininess of humid heat, steady to
her window box, parsley gone riot.
And each marigold a ruched density
caught in nettings of dill. The window,

immovably half-closed. Though cries
from the park pool, a cool depth smelling
of acetone at dark. Though the upswept
ginkgo leaves, pestered into notice

just before a storm's hard collapse.
This month, I sleep and wake to objects
assigned someone else's manners.
Given winters, the face of fear among

her three African masks, its white eyes,
cage-bar teeth. In a box, spring's silk
scarves. Year-round Christmas lights
on the bed's canopy. And in the photographs

room after room, her mother fading
into approximateness, older, then even
older, the face bones overexpressed
by age. Exhausted by heat some nights,

I have marked that difference frame to
frame, wished a means of telling

what occupied her living in between,
and arrived only at my afternoon radio's

melancholy, some onions on a plate,
a sunset left in the sky like eye shadow
on a lid. What she knew of need
imagined now as our own need, continuing,

the way our grocer's plantains, our street's
boombox merengue, stand for
what the tenement museum, blocks
from here, remembers: a yellowed letter's

Send word. The man cross-armed, posed
before his new store. And the glance
of light from the camera's flash,
touching on each sleeper on the floor.

Three Amoretti

I. Notes for Bronzino

The mouth to begin with—lightly pursed,
insouciant, as if about to say *insouciant*.
The hair needing cutting, gold, Medicean.
The eyes passing for blue, going green
in good light. Unguardedly private
as sunning cats, hands slack on his lap.
A silver ring on the right fuck-finger;
a necklace of ball bearings under
a T-shirt bleached zinc white. Then, nearly
incommunicable, each iris's black specks,
each cuticle's raw nicks. And the collar
of sunburn on his nape. The freckles
on his shoulders, pale brown and fading—
like the water stains on the bedroom ceiling.

II. On Canal & Broadway

Since you came back I've been all rhymes:
light, sight; teeth, feet; clavicle, navel.
But how to explain that I've lost track
of what it was we came *here* for?
Ginger, bancha tea, or the city's last copy
of *The Mauritius Command*? You stop to tie
your laces and the crowd curves around us,
a river glancing off stones. Couples
carrying string bags of eggplants, newspapers.
Chinese women trailing uncatalogued
bird vocables from their passing chatter.
"Here it is," you say, pointing to a door
whose lettered glass suddenly had us on it.
"Here," you say—word enough for me for now.

III. Battersea Bridge

Like signals indistinctly coming through,
the riverboats are bare blebs of light.
The next bridge is a sketch of bridge,
an arc between posts. Is there a more human
habit than this—to stand here, looking out,
letting our natures yield to all we see
so that the streets, narrowing away
to the world's edges, begin to stand for
our longings? The fog slagging over the city
would stand for our dreaming were we
sleeping, but sign after sign proves
the night OPEN OPEN OPEN. The day's grudges
are on the last trains to the suburbs.
And love, insomniac, burns in the factories.

Nearing Rome

So much open emotion that
our disbelief seemed beside the point—
"You think I want your irony,"
he said to her.
 The train shrieked
its way out of a curve. Outside, wheat
looked like the tousled hair
of someone's childhood.
 And maybe,
as in some novel which has it in mind
to curdle its characters'
good natures in the end, we would all
have to be that plaintive
and ridiculous—
 the old man interminably
peeling a boiled egg; the beautiful
dark woman reading Simenon in Spanish;
even the kid whose teeth were dirty
with purple crayon.
 And you, who hadn't
looked up in hours, even when I said
that the air coming in smelled
of sawdust, and the backyard activity
we sometimes passed—a woman hanging up

laundry, a boy spraying grain
to chickens—
 just a quaint dying memory
of an old order.

Ocean Park Notebook

I.

The worker's pants on a spider-filament line,
strung waist to waist to waist to dry.
The neat green wedge of park, always empty;
the length of concrete paced by convalescents.
The lead impastoes of interesting weather,
though mostly the shadowless blue of long days.
The sprawl of water beyond the band of beach,
copper or tinfoil depending on
the sun coming down, the moon rising.
The storefront and the thumb of hydrant
in front of it, in all kinds of light
solidly composed and unspeculative.
The garage's brick side facing a warehouse wall;
between them, the alley's cold black aisle.
The swells of a scalloped awning;
the sheetlike descent of streetwise birds.
Tubercular with rust, the flue leaking steam.
And behind the blind-eye panes, the figure
who must have chosen to be here.

II.

At a window someone watches for daybreak,
which begins for him with a spar of sun
lighting a stringcourse on the opposite building,
its tendrils and blooms freshly chiseled
when mornings have an acidly clean brightness,
or mildewed, chalky with soot, when the overcast
will not pull back from the day.
Hobbled now, but still ardent, wandering,
he looks at the postcards showing the city
and its lit grids, touches mangoes going soft
in crates, and listens always for
the murmurings: *An object, after all,*
is what makes infinity private. Spare a dollar
for a lobotomy? Everything taken up, pocketed,
added to an accrual having less to do with weight
than with lightness: the plane of a wall,
say, with pink stucco rough as emery,
and the little fish, green as muscat grapes,
selling out at a dime a dozen.

III.

Fender-chrome, gravel molars, brittle sepals
holding up the dead rose, the bottle collecting
rain—a precise light found for each
like the faded brown for leaves,
ground-down crystal for frost. The formless
moil of paint, spread into surface, depicts
the day exact. So with the persimmons
almost forgotten into ordinariness, the moons
of candle-wax on the table—things clearer somehow
for entering the orange, brown, and white
I make use of. Rising, I am elated by the light
on cold red leaves and on successive clouds,
each one edge-lit, its heart incinerate.
And the light makes use of me in ways
only line, curve, and shadow can describe,
drawn toward what pity or love that the day,
emptied but unsubdued, gives in to:
Every day he poured himself into it,
as water might pour from a flask.

The Gecko

Fresh, but faintly lurid,
the rubbing alcohol smelled keener
in the fluorescent's bleaching light;
a tray of cotton swabs, the gauze,
the drills and the needles, cleanly gleamed.
All the things a dentist
would use, but no dentist—
instead, a man wearing a Dead shirt
and a professional's dry regard,
pulling up the powdery latex gloves
a little wearily, then turning to you to ask
finally, "Which bum, left or right?"

Inscribed first, fine and black
as eyeliner, was the splayed outline:
the finger-long trunk balanced
on four flat hands, topped
by an arrowhead and tapering below
to the tail's fiddlehead spiral.
Another hour brought the spinach-green skin
to life; then, like gold under water,
a scatter of freckles on its back.
Each thumbtack eye was gorged
on something it could never blink from.
From each needle-dab, blood beaded.

And more endurable by far
than the odd late call or a stranger's glance,
what was the creature but another
design the world had on you?
So that, looking at a garish wall
of photographs, I pictured a Blakean sun
on your pec, a blue snowflake on each bicep,
each flourish offered to the mask
your face took on as the hours passed—
sated, unadmitting, at times seized
by frowns, as though in your pleasure
that look of pain was needed.

Portishead Notebook

I.

Then I woke up, the shuffle of images still with me. The water near-ice but bearable. Other figures underneath with me. Leaves floating like motes in a light-shaft. Goodbye, the kid was then saying to the car, the plastic ball by his feet white as a moon.

Convinced by the dream's exactness, all day I was moved by objects. To the lime: *Hello, Mambo.* To the paper clip: *Hello, Ponge.* I thought of your hand, flat and for once quiet on your chest. Its splay of twenty-seven bones, complicated as a spider web.

II.

Someone finally had it in them to say that the old lady's hat was now under a seat. Orange, woolen, it had picked up fuzz and a piece of foil wrapper in its slide across the floor. In her backmost teeth, the glint of fillings. Passing lights smeared the train's black windows.

Mercifully soon, the next stop. Looking up from the stairs to the street, I thought Chinese ink-wash for sky. The cold first smell of a chestnut-cart still blocks away. You have to think of it. Chestnuts. Coals. The smell that tentative, you have to think of it.

III.

I might stand on the street biding my want. The Flatiron bisects all the sky I can see. There is trash. The legless chair nodding. Wires sprung from the torn gut of plastic bag. Carpets, endured to ugliness. Dialogue of *I was really torn. Did you know I waited? Did you know?*

One room I remember had a body on a bed that I knew belonged to me but wasn't me. His pants were witless on the floor, his watch was still on his wrist. I could make out the lit numbers. The body lifted with breaths: little, little, little.

IV.

Let me tell one truth for a moment. How *landscape* seduces me into putting up the poplars and poppies even before you have told me where we are. The cows are of a color particular to this place. In the background the mountains look like dropped handkerchiefs.

As for *cities*, a friend once described a bus-ride he had to take. Providence, New Haven, White Plains. Each heavenly name. He said the bus smelled like pizza, nail polish. And then I was there, too. Knew the orphanage of each bus station he was startled to wake to.

V.

My grandfather had pockets for fried chicken in wax paper, rubber bands, casino chips, and lottery tickets he bought

assiduously but whose numbers he never checked for winners. When he died he left behind a roomful of nouns and adjectives.

This life is so fast. I remember coming across that line that goes *After such knowledge, what forgiveness.* And I was horrified that the boxes of that knowledge and that forgiveness, as the years went on, would tirelessly fill by themselves.

VI.

When I read out loud the part about the antelope going down like a tent, he worries about the tent. Tells a story about the whole afternoon it took to make the tent taut and steady, then his father cauterizing a wound with a pocket knife dipped into camp-fire embers.

I listen with my head on his stomach. The words gurgle there. There were mosquitoes, but no fish in the river. He gets hard but continues the story, tries to stay in the two worlds until the last moment. Until, finally, he is subtracted to here.

VII.

In the small forest of the city park where we find ourselves talking, sunlight's half a phenomenon of itself, half wind. One shift of the leaves' canopy lights the wedge of your jawline. With another, the glare of your eyeglass. I think, I have to try to remember everything.

The light reminds me of the three goldfish I once bought in Chinatown. Feeder fish, the clerk called them, though they grew to the size of small ficus leaves. They lived years, even on the barest care. At night I stared at them, their movements small cursives in the dark.

THREE

Aubade

Scintillas of the anatomical
on the vines, buds opening—
make me a figure
for the woken.

On the vines, buds opening—
blue, little throats.
For the woken,
this different tin sky.

Blue, little throats
speak to me in the right voice.
This different tin sky,
the playground thawing.

Speak to me in the right voice,
only clean, sweeter.
The playground thawing
into its primary colors.

Only clean, sweeter,
briary as honeysuckle,
into their primary colors
the words come: *bitter, astral.*

Briar—as honeysuckle,
as attic webs, constellated

into their primary colors.
White, or whiter.

The words come: *bitter, astral.*
Make me a figure,
blue little throats,
scintillas of the anatomical.

Phantasmal Cities

Walter Benjamin, Paris, 1940

I.

Flecked on a layer of mortar on a pillbox lid,
the tiles pieced together by a kindred myopic
have assembled this much of Tuscany:
hills worn down, yellow as old teeth,
and a marrow-colored villa rising above
olives, under which two black dogs sleep through
the afternoon heat. The size of a silver dollar,
that world seems dark and lost to him,
and when the museum's doors have been locked,
he will go outside to the flaring gaslights
on the rue de Rivoli, and to the puddles
of a January shower staring up gray
as fish-eyes on the quays.
 The stone rail
of the Pont Neuf is cold, and it is this shiver
of sudden feeling which returns everything
to him: the glint of heavy doorknobs
along Delbruckstrasse, the iron trellis-work
bracing an arcade's dusty glass dome,
above which utopias of stars shone. Again
he finds those huddled stalls in frozen Moscow:
the knife sharpener, the icon maker,
the soothsayer with his frayed divining cards.
Even the improbable ravens, tearing at

butchers' fatty scraps, fly back now to mind,
embedding themselves there like glass in masonry.

II.

A ribbon of sky roofs over the narrow street.
The tilted buildings have the weariness
of travelers who have been waiting too long;
bills hang from the trunks of kiosks
like eucalyptus peelings. Winter has hardened
the black clots of leaves and papers
in the gutters; each noise fades like ink
dropped in water. And the city has rarefied
down to stone details, as imperceptibly
as his solitude has thinned
into a fever: *The number of those*
able to find their bearings in this world
is diminishing more and more.

 Still, some nights
it is enough that a new and lucky phrase
turns his mind toward a light of its making
and restores the matrices of streets
to a believable order. Then there is no ruin
here, and his memory is as brief as day.
And the visible things remain
as the only affections he will answer for:
the daily-swept parks, and the river silver
as his room's mirror; the pearl-topped lamps
lining the bridges and boulevards;
and the dim incurious windows, reflecting
moving skies he is quickened to look up to.

III.

From out of the river-mists and gutter-fog
the blank avenues reappear nightly as stretches
of London and Prague—whose tutelary
specters, like Baudelaire's ragpickers,
he imagines with a flaneur's love.
He is enchanted by each incessant appearance:
the razed *quartiers* springing up to mock
Haussmann's imperial vistas, the barricades
raised once again, the city struggled for
and won back, even if only in his mind,
pressed to find its bearings here
among the stage-set scenery of history's mire:
the switching tracks strolled by cats,
a trolley's hollow bulk, an alley haunted
by a childhood hunchback. It takes a hero's will,
he writes, to die from one's own hand.
By now he knows the border towns have fallen
too late to stop; his papers have lapsed
like redrawn maps. Meanwhile, in his books'
gnomic lines, the past keeps occurring:
in Berlin the fish-brokers keep shouting prices,
store dummies blandly smile behind glass;
Dickens counts Holborn's hundred lamps
and Kafka coughs himself home—morning arriving
around them, the first birdsong in earshot.

IV.

Each hour turns like a wheel grinding down
bricks, metals. He is walking, breathing thickly
with his mouth open, past windows where
phantasmal cities spread their frost-maps
on the glass. In other cities it has begun—
the walls slipping, the shoes puckering
in the fires, the crosses of planes
grazing their shadows on rooftops,
cars, and squares bared as winter graveyards.
And the stunned phrases the dead gasped
fill the archives of another world,

 where the millions
are counted at last, returned to conversations
and to meals, to the noise of a midday street.
To them his city has become a past,
whose wreckage he stumbles through and sifts—
as if the charred shop-signs and statues
still landmarked the places where he last knew
what could be saved and imagined,
what was erased but furiously retrieved,
as if he were the scribe chosen to find
the words among the rubble's rings and combs.
The river stiffens into clouds of ice,
the hoary boles of chestnuts split from the cold.
Each window whitens into a city he dreams
to enter, his pockets heavy with spoons.

Montale

The shadows get to cover
the afternoon. Even birds
are folded away. A green
squash on the sill, the heart
full of seeds. The blackthorn,
berries pulped to blood

on the ground. His sleep
is one portion of shadow,
a thing cobwebbed in a corner,
something to be worked
over and over. One strand
for the kettle, the pewter-color

rain. A strand for the room,
the orchards, his father
opaque as a lover within them.
Under the tree, the wadded coat.
The way back to somewhere
is only a wish until waking.

Then the darker fall, the gust
of whiteness. The tree a lung
spread on the window.
All night, the lawn snowed upon,
blue as a shirt. Each instant
recovered, meant to grant

clarity, though what he wanted
to see has now been forgotten.
No further, and no return.
Not even the ten plagues, what
each body has to live into.
What the pharaoh lived.

Wittgenstein

centos from his notebooks

I. On Color

Try, for example, to paint what you see
when you close your eyes. Think of the colors
of polished silver, nickel, chrome,
or of the color of a scratch in these metals.

Imagine a tribe of colorblind people.
Imagine someone pointing to a place
in the iris of a Rembrandt eye and saying,
"The walls in my room should be painted this color."

There is the glow of red-hot and of white-hot,
but what would brown-hot and gray-hot
look like? We speak of a dark red light
but not of a black red light. What if someone

asked me to give the exact shade of a color
that appears to me here? How should I describe it
and how should I determine it? I don't know,
for example, whether red is lighter or darker

than blue. There is gold paint, but Rembrandt
didn't use it to paint a golden helmet.
I say blue-green contains no yellow; someone else
claims it certainly does contain yellow.

What makes bright colors bright? And what is
seeing? Suppose someone were to suggest
a traffic light be brown? We must always
be prepared to learn something totally new.

II. On Certainty

I do philosophy now like an old woman
always mislaying something, now her spectacles,
now her keys, often bewitched by a word.
For example, by the word *know*.

I know that twelve pairs of nerves
lead from the brain. I know this is a hand.
I know how the letters A and B are pronounced,
what the color of human blood is called.

Can't I be wrong? Someone might ask,
"How certain are you that that is a tree,
that you have money in your pocket,
that that is your foot? Supposing this table
alters when no one is observing it?"

I believe there are various cities.
I believe there is a chair over there.
Everything around me tells me I am in England.
Does that make me know it? Does it make it
true? Is it right to rely on our senses
as we do?

It is so difficult to find the beginning.
Or, better: It is difficult to begin
at the beginning and try not to go further back—

Is God bound by our knowledge?
How does one set about

satisfying oneself of the existence of unicorns?
Might I be mistaken in my assumption
that I was never on the moon?

At some point one has to pass from explanation
to description. For example—
A child knows which color is meant by *blue*.
A child believes that milk exists.

Or: Light dawns. This chair is brown.
Someone says, "It is raining."
The noise of the rain. The cattle in the fields.
Houses gradually turning into steam.

Interior with Extension Cord

after a painting by Elizabeth Bishop

And who wouldn't choose this room instead?

The two windows look out on the sun falling,
or, more likely, on fog moving in
in eucalyptus-smelling clouds.
The walls are thin pine slats
paint can barely hide, the wood-grain's eyes
like suns in sulfurous skies.
A sideboard has been painted Chinese white.
A full-length mirror, set in a frame
of complicated Victorian moulding,
is felted with dust.

Otherwise, the room so spare
that we bring to it what we can:
the polymer Discus Thrower with the indistinct
little prick;
three Hawaiian shirts with riotous
profusions of hibiscus and pineapples;
the chair of Thumbelina size
fashioned from braided champagne wire;
the photograph of Yeats at twenty-five.

A clock, hours and hours behind,
gives us another time that we might live by.

On a sill, three shells.
A Tomales Bay cockle scalloped
like an elephant's toenail, its inside talcy,
still salty when you put your tongue there.
Then a Mindoro oyster scabrous
as oak-bark, its lips blade-sharp,
its ridges sprouting stiff green hair.
And last, the purple-black mollusk
we never had a name for, found in Big Sur
spindrift and not thrown back.

On a stool, the paintbucket full
of what's been inexhaustibly thriving, in pink
and yellow blooms, outside.

On the table, the one lamp
which the black extension cord, stapled up
one wall, across the ceiling, down another wall,
just reaches.

—Awful, anyone else would finally think,
walking in the door
and turning back, leaving the room as it was.

Photographing the Snow

I.

Moths at the windows.
Or at least the same busy
stillness, still enough now
for the candle to stay lit
as it's held through
the walk to the shed.
The flame bends, moved
but staying, the flakes
now moths to it,
pooling around the saucer.

II.

What starts as one syllable
or smallest underfeather
turns inexplicable
on the frozen glass strip.
Seen in the microscope
and photographed like
a face, the graph
of features is no less a thing
visited by meaning,
despite its randomness.

III.

Paper makes more noise.
The shredded hush.
The unsorted pieces falling.
Falling so that now
you have me. The green straw,
lantern, oil-black
leaves. Now you have me.
Shovel, fence, horse's
shoe sparking off
the rail, the startled fact.

At Point Reyes

I was old. I could see this in the will
of the ocean moving in, the lavish force.

Among the seaweed were finger bones
of driftwood, some feathers, flame-blue

and teeth-white. The water was the same
as I had known it: light green within

the thinning wall of its arc, the horizon
behind it. I felt separate but unhurt,

the smallest trapeze swinging on inside
my chest. From the pieces eroded

to chalk by the sand, I had to remember
what it meant to have ruined something,

bottle after bottle cracking against rocks.
Dead things, souring in the salt air:

this was my exhaustion. The ice plants
glistened plastic pink, the poppies furled

into bullets. I started to get cold, cold
as a leaf on someone's palm. A line of

breath followed everything that I said
to myself. Somewhere in the cordgrass

I found a pair of glasses, an insect-leg
tangle of rusted wires. The sunset began

to answer the things I had my heart on:
the snowglobe city, its durable lights;

the view from a window down to wet cars,
each roof a nail painted in black polish.

Miró's Notebook

I.

Dusk, thus:
a shirt drops,

the bellybutton rune
showing.

Clouds are soaked,
the sea now

iron, muscle-heavy.
The pond begins

reflecting on astronomy.
The fruit wait.

The furniture
call back their atoms.

The tree asks for
its leaves.

II.

Winter brought into the room
is the whisk of holly.

The purse is a hare limp
on the table, its eye
gone amber.

The birdcage is the work
I am after: gold-barred,
so no bird leaves.

The celadon throat, the iceberg
teeth, the matted grass
of an armpit...

A pear, or maybe a stone,
the chilled shoulder shifts under
cover, not persuaded
into similitude.

III.

In the snail-tracked sky,
the mineral grains, a dozen eyes.

You tell me thread
is for seam and hem, not the mica
bead-stitched on the dark.

You refuse to have the shards
the broom gathered
be the moon, seen as aftermath.

But like the thimble, I have no guile.

So let your window
open to the rain coming down,
drumming on the hidden shells.

IV.

Black cherries.
Glass of milk on a tablecloth.
An arm of bread.

The coins.
Green scarab beetle.
The compact's sleeping mirror.

The fig branch.
The sundial.
The harlequin leaves.

V.

Votive-light evening,
cipher ridden.

The marsh air, and my finger
in places.

Among the lesser constellations,
the fractured

kite, the anemone.
The geese thread-pulled

into the hard sleep.
The clothespin, the gold

in your hair.
The seeds spread

are a flung field.
I sleep on stone, you on moss.

VI.

The red-haired figure
in the station, the man selling
carnations. The scarecrow

landscape, the suitcases
getting heavier with every stop.
Those served as props.

I dreamed we each played a part.

One of us was given to say:
I wanted your distance whispered down
small enough for this room.

And one to say:
I saw you always just a little
out of reach, with white hair.

VII.

A fish-scale moon:
who doesn't want

to be left used,
windsock-hollow?

Now for morning:
the lit wick

of each grass-blade,
the saplings

like legs of deer,
the four walls

verifying the house,
and the slip

of last night's chive
in your teeth.

The Author

———

Karim Logue

Rick Barot

is currently Jones Lecturer in Poetry at Stanford University. He was born in the Philippines and grew up in the San Francisco Bay Area. He attended Wesleyan University, the Writers' Workshop at the University of Iowa, and Stanford, where he was a Wallace E. Stegner Fellow in Poetry. His poems have appeared or are forthcoming in numerous publications, including *The Yale Review*, *The Threepenny Review*, *New England Review*, *Grand Street*, and *Ploughshares*. In 2001, he received a poetry fellowship from the National Endowment for the Arts. He lives in Oakland, California.

Previous Winners
The Kathryn A. Morton Prize in Poetry

1995
The Lord & the General Din of the World by Jane Mead
Selected by Philip Levine

1996
When by Baron Wormser
Selected by Alice Fulton

1997
The Gatehouse Heaven by James Kimbrell
Selected by Charles Wright

1998
Garden of Exile by Aleida Rodríguez
Selected by Marilyn Hacker

1999
Summons by Deborah Tall
Selected by Charles Simic

2000
World's Tallest Disaster by Cate Marvin
Selected by Robert Pinsky